Date:

..

This book belongs to:

..

A
Savior
IS
Risen

AN *Easter* DEVOTIONAL

SUSAN HILL

ZONDERVAN®

ZONDERVAN

A Savior Is Risen

© 2024 Zondervan

Requests for information should be addressed to:
Zondervan, *3900 Sparks Dr. SE, Grand Rapids, Michigan 49546*

ISBN 978-0-310-46313-9 (audiobook)
ISBN 978-0-310-46322-1 (eBook)
ISBN 978-0-310-46323-8 (HC)

Art direction: Tiffany Forrester

Interior design: Kristy Edwards

Photography: Noelle Glaze

Printed in Malaysia

24 25 26 27 28 OFF 10 9 8 7 6 5 4 3 2 1

Contents

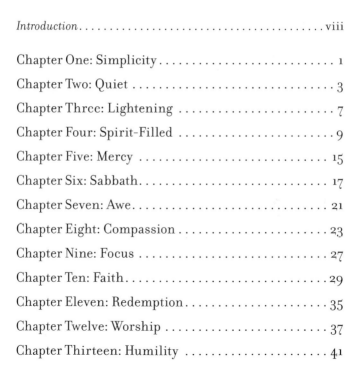

Introduction

It's impossible to overstate the significance of Easter. After all, the life, death, and resurrection of Jesus Christ are the foundation of the Christian faith. But, if we're honest, the magnitude of it all is challenging to wrap our minds around. To attempt to understand the depths in one sitting would be like taking a sip of water from a fire hydrant—it's too much! To engage fully, we need time to prepare our hearts and minds. The good news is that the Lenten season provides that opportunity.

A Savior Is Risen invites you to slow down and focus on your faith. Spending just a few minutes each day will allow you to read a scripture, ponder the meaning, and reflect on how it impacts your life. As you focus your thoughts on God's redemptive story, by Easter Sunday you'll be ready to celebrate the risen Savior like never before.

You might choose to use a journal during these forty days to record new thoughts and insights, or perhaps you'd rather

just read along. There's no way to do it wrong—the goal is to fix your gaze on Jesus. So grab a cup of coffee or tea, find your favorite chair, and let's get started!

Simplifying means

refocusing

your attention on God.

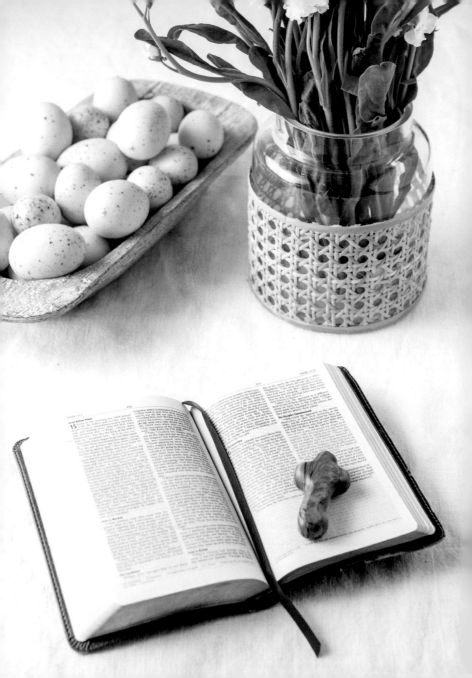

Simplicity

One thing I ask from the Lord; this
only do I seek: that I may dwell in
the house of the Lord all the days of
my life, to gaze on the beauty of the
Lord and to seek him in his temple.

PSALM 27:4

Numerous things compete for our time and attention. Our days are filled with family responsibilities, tasks at work, errands, chores, and a constant stream of alerts coming to our phones, leaving us feeling pulled in several directions. Distraction is the new normal. Many of the things we are juggling are undoubtedly good things—but the pace is exhausting. Maybe it's time to scale back. Simplifying doesn't mean ignoring our responsibilities or backing out on commitments. It simply means refocusing our attention on God.

If the thought of simplifying makes you nervous, you're

not alone. In the Gospel of Luke, two sisters named Mary and Martha were hosting Jesus in their home. Martha was exhausted from her never-ending list of tasks, and she was irritated with her sister, Mary, who was just sitting at Jesus' feet listening to Him teach. But when Martha complained to Jesus about her sister, Jesus gave her a response she didn't expect.

"'Martha, Martha,' the Lord answered, 'you are worried and upset about many things, but few things are needed—or indeed only one. Mary has chosen what is better, and it will not be taken away from her'" (Luke 10:41–42).

If you're wanting to simplify, Jesus encourages you to focus your gaze on one thing—Him! As you focus on Jesus, you'll be better equipped to care for your people and meet your responsibilities.

Lord, teach me to prioritize my schedule in a way that reflects You as my main priority.

Quiet

He makes me lie down in green pastures,
he leads me beside quiet waters, he
refreshes my soul. He guides me along
the right paths for his name's sake.

PSALM 23:2–3

Spring brings the promise of warmer temperatures, blooming flowers, and fresh foliage. When winter clouds hide the sun, when the trees are bare, the birds have gone silent, and it's cold outside, it seems unlikely that anything new is preparing to bloom. For a time, nature is quiet. To the naked eye, it appears that nothing is happening. But below the surface, a cycle is in motion, preparing new growth to appear in due season. In the quiet days of winter, growth and change are taking place.

Spiritually speaking, you, too, need quiet time to grow. Moments of stillness and silence are vital, because they give

you time to evaluate your faith. They allow you the opportunity to contemplate where you've been and imagine where you want to go. Maybe you're someone who embraces the hustle and the rapid pace most of us have grown accustomed to. If so, there's nothing wrong with that, but don't grow discouraged when things are quiet. God is always at work, even during times when it seems as if nothing is happening.

Lent is an ideal time to embrace the quiet. Do you need to hear from God? Would disengaging from all the noise provide you some much-needed clarity? Would some solitude give you a chance to recalibrate? Do you need to rest and recharge? Go ahead—you've got God's permission.

> *Lord, thank You for encouraging times of stillness and rest. Help me seek quiet times so I can hear You and be renewed by You.*

God is always at

work.

THREE

Lightening

"Take my yoke upon you and learn from
me, for I am gentle and humble in heart,
and you will find rest for your souls. For
my yoke is easy and my burden is light."

MATTHEW 11:29-30

Imagine carrying a heavy bag with you everywhere you go.
Not only is it heavy, but it's also awkward and hard to grasp,
so you're always setting it down and picking it up again. You'd
love to leave it somewhere and go about your business, but its
contents belong to you, and you're unsure where to put it. The
bag limits where you can go, and at the end of the day, you're
exhausted from carrying it.

Sound familiar?

Everyone has baggage that piles up from years of living
in a broken world. Maybe your bag is filled with things you'd
like to get rid of—regrets, secrets, shame, fear, worry, anxiety,

embarrassment, or unconfessed sin. Or perhaps your bag is heavy from an overbooked schedule or chronic stress, and you are teetering on the edge of burnout. Jesus knows what it's like to carry the weight of the world on His shoulders—He did so on the cross. And because He did, you don't have to.

In our verse from Matthew, Jesus spoke of an easy yoke. In first-century farming communities, a yoke went across the necks of two farm animals pulling a plow. It lightened the load, so neither animal was taxed beyond their capabilities. Do you need a lighter load? Jesus invites you to drop your baggage at the foot of the cross. Those sins you are still carrying? He dealt with those at Calvary. Those ongoing burdens? Jesus doesn't intend for you to carry those alone—He will help you carry them.

Jesus, teach me to place my burdens at Your feet. Thank You for never leaving me to carry them alone.

FOUR

Spirit-Filled

"And I will ask the Father, and he will
give you another advocate to help
you and be with you forever."

JOHN 14:16

Have you ever felt far from God? Like you outran Him, and He can't keep up? One of the most mind-blowing truths of the Christian faith is that the same Spirit who raised Jesus from the dead lives in us (Romans 8:11). As believers living on this side of the cross, we don't have to wait as the disciples did for the coming of the Holy Spirit. If you are a Christ follower, the Holy Spirit already resides in you (v. 9).

Before Jesus' death, His disciples had grown increasingly anxious. They didn't fully comprehend what was about to happen at Calvary, so Jesus had a conversation to prepare them. Knowing they would be unsure of how to proceed in His absence, Jesus told them about the coming of the Holy Spirit.

He referred to the Holy Spirit as an "Advocate" and the "Spirit of truth" and assured them the Holy Spirit would reside in them (John 14:16; 16:13). Until that point, Jesus had been with the disciples in bodily form, but after His death and resurrection, the Holy Spirit would live in them—and all believers to come.

The Holy Spirit has several roles in your life: He teaches you (John 14:26), convicts you of sin (John 16:7–8), increases your wisdom (Ephesians 1:17–18), leads and guides you (John 16:13), gives you spiritual gifts (1 Corinthians 12:4), prays for you (Romans 8:26–27), and much more. Jesus didn't leave the disciples to fend for themselves, and He didn't leave you—He sent the Holy Spirit to dwell in you, which means you are *never* without divine help. Ask for wisdom from the Holy Spirit. He is at work in you.

Jesus, thank You for the presence of the Holy Spirit. Teach me to be sensitive to His presence and obey His promptings.

You are *never*

without

divine help.

God pours out

mercy

instead of judgment.

Mercy

"Go and learn what this means: 'I desire
mercy, not sacrifice.' For I have not come
to call the righteous, but sinners."

MATTHEW 9:13

It's overwhelming when we find ourselves in a mess of our own making. Maybe we made a poor decision, acted impulsively, or flat-out sinned against God. When we know we are wrong, the guilt can feel crushing. When other people sin against us, we are often inclined to ask for vindication and pray, "Lord, I want justice!" But when *we* are the offender, we are in no position to ask for justice—we are dependent on God's mercy.

To receive mercy means that even though we are guilty, we do not receive the punishment we deserve. God's mercy doesn't minimize sin, but it offers a reprieve to guilty offenders. Jesus took the penalty for our sin, and therefore, God pours

out mercy instead of judgment. When you need mercy, ask for it! You might be tempted to think God has a limited amount of mercy and you can out-sin His love for you, but that's simply not the case. The Bible says, "The steadfast love of the Lord never ceases; his mercies never come to an end; they are new every morning; great is your faithfulness" (Lamentations 3:22–23 esv).

An ever-increasing awareness of God's mercy makes your relationship with Christ that much sweeter. Jesus said those who have been forgiven much, love much (Luke 7:47). Spend some time thinking about the specific ways God has shown you mercy and how you can extend mercy to others.

Lord, thank You that You are a God of mercy and that Your mercies are new every morning. Teach me to embrace Your mercy so I can be merciful to others.

Sabbath

There remains, then, a Sabbath-rest
for the people of God; for anyone who
enters God's rest also rests from their
works, just as God did from his.

HEBREWS 4:9–10

Our bodies function around a circadian rhythm—an internal clock that follows a twenty-four-hour cycle and takes its cues from light and darkness. Within that cycle, God wired our bodies with a need for rest each day, and He commands a scheduled day off each week. The physical, mental, and spiritual aspects of our bodies are intertwined, and the Sabbath serves to refill all three. God modeled this rhythm when He created the heavens and the earth—working six days and resting on the seventh (Genesis 2:3).

As you prepare your heart and mind for Easter, reflect on your own personal rhythms. Do you typically carve out rest

for yourself one day a week? It doesn't have to be on Sunday—it can be any day of the week. Rest might mean a long nap after church, reading a book, going to a park, enjoying a special meal, or spending time outside to unwind. The Sabbath is a time to worship, recharge, and rest in the finished work of Christ. It's a time to reflect on your relationship with God and delight in His grace (Ephesians 2:8–9). Just as Jesus emphasized, the Sabbath is intended to be a blessing and not an added burden to those who observe it (Mark 2:27).

Lord, thank You for the innate way You designed my body. Help me to prioritize the Sabbath. Teach me to embrace rest as a spiritual discipline.

The Sabbath is a time to

worship,

recharge,

and rest

in the finished work of Christ.

Awe

LORD, I have heard of your fame; I stand
in awe of your deeds, LORD. Repeat
them in our day, in our time make them
known; in wrath remember mercy.

HABAKKUK 3:2

When was the last time you marveled at a sunset, paused to study the beauty of a flower, or were brought to tears by a passage of Scripture? If life seems dull and monotonous, there could be a couple of culprits. One, you may be depressed. If so, I'm sorry—you might benefit from talking to a therapist or a Christian counselor. Or perhaps you've misplaced your awe of God. You were designed with an innate desire to worship, so if you aren't worshiping God, you are likely worshiping a counterfeit god that will leave you unsatisfied. What makes this cycle tricky is that you might not even realize you've fallen into this

trap—without intending to, you've allowed it to become life as you know it.

Shortly after Jesus' resurrection, two disciples were walking on the road together, discussing the events that had taken place and debating whether Jesus had risen from the dead (Luke 24:13–35). As they walked, Jesus joined them on the road, but initially, they didn't recognize Him. Later, after they realized they had encountered Jesus, they asked each other, "Were not our hearts burning within us while he talked with us on the road and opened the Scriptures to us?" (Luke 24:32). Even though they hadn't realized this man was Jesus, they found themselves in awe of Him.

Walking with Jesus leads to awe. If you'll follow Him, ponder His works, meditate on His ways, esteem His character, and keep your eyes open, you'll live in awe of a risen Savior. God has created a world that is awe-inspiring. Ask Him to open your eyes to the marvels all around you.

Lord, I don't want to live my life in a world of monotonous gray. Increase my awe of You. Teach me to keep my eyes open, so I can see You at work and be in awe of You.

Compassion

When he saw the crowds, he had
compassion on them, because
they were harassed and helpless,
like sheep without a shepherd.

MATTHEW 9:36

When we are on the receiving end of compassion, it feels like the first warm day after a long winter. Compassion can be shown in different ways: it might come as a long talk with a good listener, a meal dropped off at your door, a reassuring glance, a friend sitting with you in a waiting room, or a handwritten note. Compassion replaces the well-intended phrase "Call if you need anything" with the question "How can I help?" Compassion doesn't avoid people who are suffering; instead, it looks them in the eyes and silently says, "I'm not going anywhere."

As Jesus traveled to towns preaching and healing the sick,

He was moved by what He saw and wanted to alleviate their suffering. Scripture says, "When he saw the crowds, he had compassion on them, because they were harassed and helpless, like sheep without a shepherd" (Matthew 9:36). Compassion flowed effortlessly from Jesus as He fed over five thousand guests, healed the untouchables, wept with His friends, and ultimately walked to the cross to give His life for you and me.

During the Lent season, take some time to reflect on Christ's compassion, and look for it in your own life. How can you extend more compassion toward your family, your coworkers, your fellow church members, or even people you pass in the grocery store? Pray that God would help you slow down and see more opportunities to be kind. When was the last time you were on the receiving end of compassion? Thank God for it! In a world that is quick to anger, compassion is the antidote to hostility. Compassion silences bullies, soothes hot tempers, and motivates the weary to continue pressing on.

Jesus, help me to receive Your compassion so I can freely extend it to others.

Compassion

is the antidote to hostility.

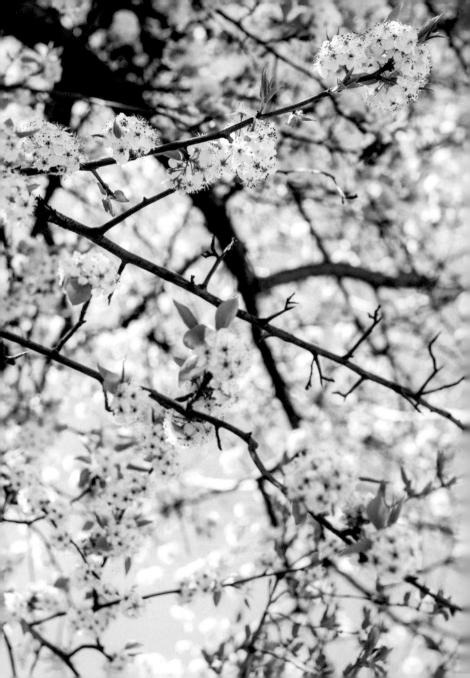

Focus

Fixing our eyes on Jesus, the pioneer
and perfecter of faith. For the joy
set before him he endured the cross,
scorning its shame, and sat down at
the right hand of the throne of God.

HEBREWS 12:2

Have you ever logged on to social media for "just a minute" and realized an hour later that you were still scrolling? Technology has its advantages, but it has also caused us to be increasingly distracted. These days, it isn't uncommon to be thinking about several things at once—but certainly not with any depth. This presents a challenge because the Christian faith demands that we engage our minds. Jesus told His followers that the most important commandment was to love God with all our hearts, souls, and *minds* (Mark 12:30). Technology

is here to stay, so it's important that we learn to manage it without forfeiting our focus.

What if, during the days leading up to Easter, you committed to focusing on your relationship with God? This doesn't mean you have to live like a monk, take a vow of silence, or go on a retreat—unless you want to! Simply spend time each day focusing on Jesus. That might mean turning off your phone for a few minutes to read your Bible. Or you might go for a walk to pray and write down your thoughts in a journal. Find what works best for you. It doesn't matter how you focus your mind on Jesus—it just matters that you do.

Jesus, You are worthy of my undivided attention. Teach me to focus my thoughts on You. Help me to be intentional about managing my thoughts so I am not distracted from the things that matter most.

Faith

"Truly I tell you, if you have faith as
small as a mustard seed, you can say
to this mountain, 'Move from here
to there,' and it will move. Nothing
will be impossible for you."

MATTHEW 17:20

Few things are as lovely as a well-kept garden, whether in a backyard or a spacious public park. Delicate tulips in the spring, lush roses and peonies in the heart of the summer. As we plant the small seeds, we wonder, *Will it take root and grow? What type of environment will it thrive in? And if the seed grows, will the plant come up hardy, or will it be taken out by the first storm?* But the unremarkable appearance of a seed is misleading. It might not look like much, but inside, it's bursting with potential.

Your faith is similar to a seed. Jesus even used the example of a mustard seed as an analogy when teaching His disciples

about faith (Matthew 17:20). Your life as a Christian began as a seed of faith—that was the moment when you believed that God loved the world so much He gave His only Son and that those who believe in Jesus will experience eternal life (John 3:16). That's the good news of the gospel and the message of the Easter season. But your faith journey doesn't stop with the initial act of believing—that is just the starting point.

The apostle Paul said, "The righteous will live by faith" (Romans 1:17). But what does that mean? It means your faith holds the capacity to grow as you experience answered prayer time and time again. It means you look at the answered prayers in the lives of others and throughout history, and you grow in your faith. Pray that God would grow your faith over time, like a garden—seed by seed, bloom by bloom. No garden in this world can compare.

Lord, I pray You will increase my faith. Let my faith be deeply rooted and grow in every season of life.

Jesus

rescued

us from the

dominion of darkness

and made us

citizens

of the

kingdom of God.

Jesus

knew every sin this

world would commit,

and He chose to

love

us anyway.

Redemption

For he has rescued us from the dominion
of darkness and brought us into the
kingdom of the Son he loves, in whom we
have redemption, the forgiveness of sins.

COLOSSIANS 1:13–14

It's a storyline we've seen unfold in numerous books and movies—the character we are rooting for goes through a harrowing situation and, at the last minute, is saved from disaster. We love a suspenseful story with a happy ending. It's not unlike God's story of redemption, which unfolds in the pages of Genesis to Revelation and reaches a pinnacle at the cross.

You've probably sensed there's something broken in our culture. It takes only a quick scroll on social media to convince us of that. And as we see the darkness in the world, if we're honest, we know that same darkness lurks in our own hearts. It's easy to grow tired, fearful, or bitter as we struggle with the

same sin time and time again. But if we know Jesus, we have a better answer than despondency.

Today's scripture tells us that Jesus rescued us from the dominion of darkness and made us citizens of the kingdom of God. During the Lent season, it's beneficial to look back and consider what Christ has redeemed us from—all that's wrong with the world and all that's wrong within our own hearts. As children of God, we get to draw near to our Redeemer even in the brokenness. Rather than grow fearful at all the negativity, we can invite a spirit of confidence and ease, knowing that we're not doing this alone. Jesus knew every sin this world would commit, and He chose to love us anyway. Next time you observe brokenness in the world or brokenness within yourself, view this as an opportunity to love.

Jesus, I praise You for redeeming me. Help me to understand with increasing measure how my fate changed at Calvary. Help me to look back with reverence and look forward with gratitude and anticipation.

Come, let us bow down in worship, let
us kneel before the L ord our Maker.

PSALM 95:6

How do you worship? Maybe it's with old hymns and quiet prayers. Or perhaps you prefer raising your hands and singing exuberantly. Expressions of worship vary as widely as the people offering the praise. Although there can be many ways to worship, Jesus did say the Father desires for people to worship "in the Spirit and in truth" (John 4:24). That means our worship should be heartfelt and based on the truths of Scripture. But as long as the outward expression matches the inner conviction of our hearts, the method is up to us.

Jesus' resurrection is more than enough reason to praise God. But the truth is, God continues to bless and is constantly providing new reasons to worship and give thanks. This Easter season, look for opportunities to incorporate more worship

into your daily spiritual rhythm. Invite a spirit of gratitude as you thank God for who He is and how He continually shows up in your life.

Consider finding someone else to worship with, whether it's in your family or church, or it's just with a good friend. It doesn't need to be formal—maybe a small gathering of friends in your living room or at the kitchen table, or a prayer group in a local park. Whatever it takes for you to direct your spirit on the magnitude of God. Notice how you feel after each occasion and how your emotions change over time. Praise can change our hearts in ways we would never expect.

Lord, You are worthy of all worship, praise, and thanksgiving. Teach me to worship You in spirit and truth. Help me to prioritize worship.

God continues to

bless

and is constantly

providing new

reasons to

worship

and give thanks.

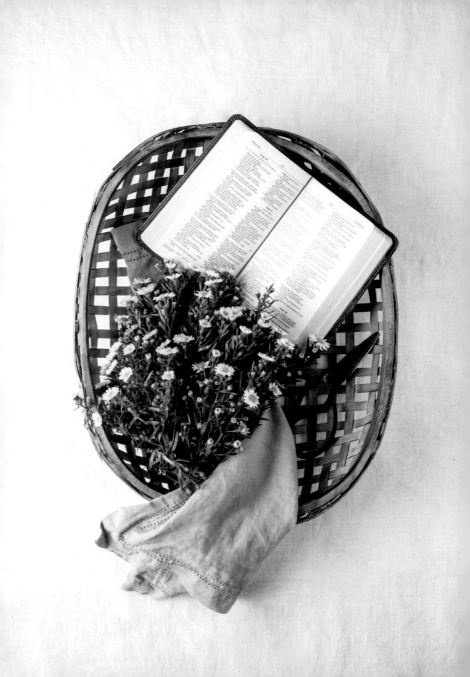

Humility

And being found in appearance as a
man, he humbled himself by becoming
obedient to death—even death on a cross!

PHILIPPIANS 2:8

As the Son of God and Savior of the world, Jesus could have preached with pride and condemnation, but He never did. God could've chosen for Jesus to be born into a prominent and wealthy family; instead, He was born into humble circumstances. Jesus could've spent His thirty-three years on earth focusing on self-glorification, but instead, His goal was to bring glory to the Father. Although Jesus had the option to turn His back on His mission, He humbled Himself to the point of death on the cross (Philippians 2:8). At every fork in the road, Jesus chose the humble path.

The apostle Peter wrote, "Humble yourselves, therefore, under God's mighty hand, that he may lift you up in due time.

Cast all your anxiety on him because he cares for you" (1 Peter 5:6–7).

What does it mean to live with humility? It means in order to love your neighbor, you should lay down your privilege and position and choose kindness and meekness instead. Humble living doesn't mean you should shelve your ambition—some of the most productive people in the world are the most humble. Humility means approaching your work and goals with the objective of serving God and helping other people.

Humility may present differently in every culture and generation—it's up to you to look for opportunities to make your life service-oriented. How can you encourage a peer at work and celebrate their talent? How can you surrender your time to volunteer at local nonprofits? How can you commit a portion of your income to help someone else? When done with a pure heart, these actions are all ways to participate in humble living. Identify one way you can actively humble yourself before your neighbor and contribute to Christ's mission of love. As you do, watch how God changes you.

Lord, I pray You will teach me to humble myself before You and my neighbor. I pray my life will bring You glory and be of service in Your name.

Believe

Then Jesus told him, "Because you
have seen me, you have believed;
blessed are those who have not
seen and yet have believed."

JOHN 20:29

D oubt tends to creep in at unfortunate times. In pivotal
moments, when we need mountain-moving faith, doubt
whispers, *Does God hear my prayers? Why hasn't He fixed this
situation? How long will this continue?* Often, when we experience doubt, we put on our game face and pretend all is well—but
there's a better way.

After Jesus was resurrected, the apostle Thomas struggled
to believe the reports about Jesus being alive. Thomas said,
"Unless I see the nail marks in his hands and put my finger
where the nails were, and put my hand into his side, I will not
believe" (John 20:25).

Sounds pretty cynical, right? Maybe so cynical that Jesus might write off Thomas? Hardly. Rather than dismissing Thomas because of his doubts, Jesus invited Thomas to take a closer look. A few days later, Jesus appeared to the apostle and said, "Put your finger here; see my hands. Reach out your hand and put it into my side. Stop doubting and believe" (John 20:27). When Thomas leaned in and took a closer look, he said, "My Lord and my God!" (John 20:28).

The remedy for doubt is taking a closer look at Jesus. No, you can't reach out like Thomas did and touch Jesus' flesh—but you can study His Word. You can study history. You can study science. You can wrestle with the Scriptures and voice your questions in prayer. Jesus invites you to lean in closer and express your doubts—it's the process that strengthens faith.

*Lord, like Your disciples, I pray, "I believe, help my unbelief"
(Mark 9:24). When I struggle with doubt, teach me to look
for the answers in Your Word and fill me with Your faith.*

The

remedy

for doubt is taking a

closer

look at Jesus.

Communion

And he took bread, gave thanks and
broke it, and gave it to them, saying,
"This is my body given for you; do
this in remembrance of me."

LUKE 22:19

F ood is often at the center of our holiday celebrations. Perhaps you have a tradition of going to the same restaurant every year on your birthday or making a secret family recipe every Easter. There's something special about gathering around a table and sharing a meal, and it's even better when it's part of a long-standing tradition shared with those you love.

Communion is a celebration of remembrance. When Jesus held up the bread and cup and said, "Do this in remembrance of me," He was teaching His disciples and all believers that the bread represented His body and the cup represented His blood, which would soon be poured out as a payment for sin. When you

take communion, you are remembering and celebrating that Jesus saved you—the whole of you. There is no sin that He can't cover with His blood.

Taking communion is a beautiful tradition that has been held by the church for centuries. Although the elements are generally given in small portions, this meal will fill you for a lifetime. When you gather to take communion, you are obeying the words of Jesus by remembering His life, death, and resurrection. It's a family meal—intended to be shared with other believers. Next time your church offers communion, thank God for inviting you to the best table of all, and imagine what it will be like to one day dine with Him in heaven.

Lord, I want to live my life in constant communion with You and Your people. Thank You for the gift of communion— I observe it in honor of You.

Listen

"My sheep listen to my voice; I know
them, and they follow me."

JOHN 10:27

L istening well has always been a challenge, but never
more so than in the age of digital distraction. There are
constant banners running across the tops of our screens. A
never-ending flow of text messages and emails. News at all
hours. It's harder than ever to tune in to the present moment.

Perhaps you've been with a friend who was constantly
checking their phone. (Or maybe that's been you at some point!)
It's difficult to have a robust conversation when one person
isn't tuned in and fully engaged in the discussion. Spiritually
speaking, when you commit to slowing down and really lis-
tening to the voice of God, you will enjoy the conversation *so
much more*. When was the last time God spoke to you through

a passage of Scripture, an answered prayer, a nudge, or a quiet inner-knowing?

Consider setting aside some time to sit quietly before God. Treat this like a dinner with an old friend. Put the phone away and listen to the words Jesus speaks. Don't be discouraged if it takes time for your mind to get quiet and focus. If your thoughts tend to wander, read a passage of Scripture and spend several minutes thinking about what it means. Or perhaps the quiet time before God will lead you to pray.

Lord, I want to hear You speak. Help me to know You so well that I can distinguish Your voice from all the others. Teach me to be a good listener.

Consider setting

aside

some time to sit

quietly

before God.

Salvation

is a gift of God's

grace

and is not earned by works.

Grace

Jesus answered him, "Truly I tell you,
today you will be with me in paradise."

LUKE 23:43

W e tend to buy our friends gifts that are equivalent in value to the ones they give us. After all, it's awkward when the gifting is out of balance. We often prefer to earn our wage, pay our own way, and do our part. Those are all excellent qualities—but they don't apply when it comes to salvation.

As Jesus hung on the cross, He was surrounded by two men who were guilty of committing crimes and had been sentenced to death. One of the criminals insulted Jesus and taunted Him, saying that if He was indeed the King of the Jews, He should save them and Himself (Luke 23:39). The other criminal recognized that Jesus was the Son of God and told the man they were being punished justly because they were guilty, but Jesus had done nothing wrong. Then the man said, "Jesus, remember

me when you come into your kingdom" (v. 42). Jesus answered him, "Truly I tell you, today you will be with me in paradise" (v. 43).

Jesus promised this man paradise, and he didn't have to do anything except believe. The grace of Christ is extravagant, and the price is high—it cost Jesus His life. And yet, Jesus gives grace freely. The criminal Jesus saved on the cross never had the opportunity to do any good works—yet that same day, he was with Jesus in heaven. Salvation is a gift of God's grace and is not earned by works (Ephesians 2:8–9). It should be celebrated and embraced with gratitude.

It may be tempting to think that being a good Christian relies on keeping a set of firm rules—that you can impress God enough to get into the gates of heaven. But it's simply not true. By Christ, and Christ alone, will you be saved. So rejoice! Christ's work is already done, and His grace is for you.

Lord, thank You for being a God of grace. Help me to be quick to give grace to others—in the same way You've lavished grace on me.

Hope

May the God of hope fill you with all
joy and peace as you trust in him,
so that you may overflow with hope
by the power of the Holy Spirit.

ROMANS 15:13

People need hope like spring plants need rain. Without hope, growth wanes. But often that hope ebbs and flows. Some days it seems there are plenty of reasons to be hopeful. But then something happens and, for a time, things look hopeless. How can we hold on to hope when things look hopeless?

Reflecting on our history with God is an effective tool for refilling hope. During a difficult time, the psalmist wrote, "I remember the days of long ago; I meditate on all your works and consider what your hands have done" (Psalm 143:5). The key words here are *remember*, *meditate*, and *consider*.

The cross of Christ is a vivid reminder that God went to

extravagant lengths for us. The apostle Paul raised an important question: "He who did not spare his own Son, but gave him up for us all—how will he not also, along with him, graciously give us all things?" (Romans 8:32). If God was willing to give us the ultimate gift in Jesus, we can be confident that He will provide the lesser things.

This Lent season, take time to remember, meditate, and consider. Remember the ways God has come through for you in the past. After all, He has brought you this far! Meditate on specific scriptures that apply to your situation. Consider God's character and track record of faithfulness. Ask Him to refill you with hope.

Lord, I pray You will refill me with hope. Teach me to remember our history, meditate on Your promises, and consider Your ways. Thank You for being the God of hope.

People need

hope

like spring plants need

rain.

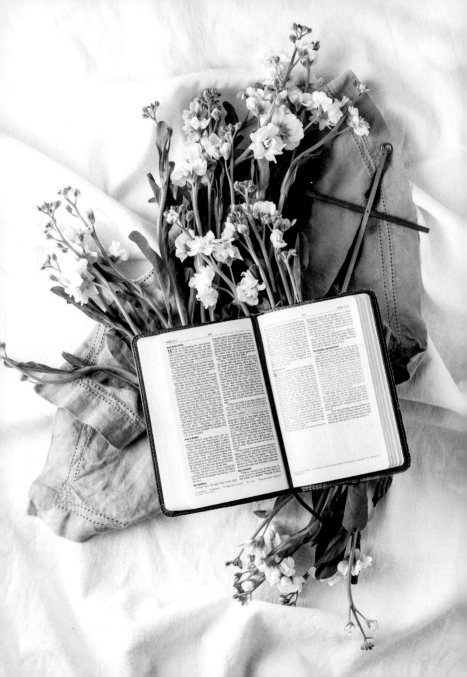

Mission

"For the Son of Man came to
seek and to save the lost."

LUKE 19:10

Every company has a mission statement, which often dictates how it spends its money and who it partners with to get things done. Similarly, as Christians, we have a mission—whether we've articulated it or not. Knowing our mission brings clarity because when we say yes to our mission, we say no to things that don't align with it.

Jesus' mission was to seek and save the lost (Luke 19:10). Jesus was regularly preaching, teaching, discipling, healing, and serving all kinds of people. His roles were varied, but everything He did was motivated by His mission.

God intends for us to live a life filled with purpose and meaning. We have talents, skills, experiences, and spiritual gifts. So many people seek their personal calling, but Jesus

made it easy—just go and make disciples. If we're doing that, we're on track! No elaborate career plans required!

Each day, we can contribute to the kingdom of God by serving the world around us. How would you describe your mission? What are your personal strengths? How can you use those strengths to help people know Jesus? Brainstorm a few ways you could lean practically into your strengths to further God's name. Display those ideas on the refrigerator or a mirror—somewhere you can see them every day. Consider which ones stand out to you over time, and pray that God would empower you as you step out to do work in His name.

Lord, help me to live every day of my life on a mission. Please give me clarity about my mission, and empower me to do the work You intend for me to do.

Prayer

Going a little farther, he fell with his face
to the ground and prayed, "My Father, if
it is possible, may this cup be taken from
me. Yet not as I will, but as you will."

MATTHEW 26:39

P rayer changes things. Sometimes prayer changes our
circumstances, and other times prayer strengthens us to
endure our circumstances. Jesus modeled a life of prayer, ris-
ing early to pray, staying up all night to pray, and even slipping
away from the crowds to pray. Jesus made prayer a lifestyle, not
a last resort. So when Jesus' darkest hour arrived, it's not sur-
prising that He took His three closest disciples and got away
to pray.

When Jesus reached the garden of Gethsemane, He prayed
and asked God to remove His cup of suffering (Matthew 26:39).
When we're struggling, we can ask God simply to remove the

problem—because sometimes He does! Jesus prayed a second time, and then a third (v. 44). Then something fascinating happened. When Jesus finished His third prayer, He woke up His friends and said, "Are you still sleeping and resting? Look, the hour has come, and the Son of Man is delivered into the hands of sinners. Rise! Let us go! Here comes my betrayer!" (vv. 45–46).

As Jesus prayed, a dramatic transition occurred—He went from being full of sorrow and distress (v. 37) to rising to fulfill His mission (v. 46). The Father hadn't changed Jesus' circumstances—Jesus was still going to the cross—but the Father provided Jesus with the strength He needed to conquer the most challenging feat in world history.

None of us can ever comprehend what Jesus endured that day, but we can grow in our confidence, knowing we have the same access to God that Jesus did. If Jesus needed to pray, then how much more should we? What would our lives be like if we made prayer a regular conversation throughout the day? This Easter season, look to Jesus' example and set aside some time to get away and pray. Look for opportunities to commune with God in your car, at your desk, or on a walk. God can change your circumstances, but if He doesn't, He will still change your heart.

Lord, teach me to devote myself to prayer. Help me to make prayer a first response rather than a last resort.

If Jesus needed to

pray,

then how much

more

should we?

Unity

"My prayer is not for them alone. I
pray also for those who will believe in
me through their message, that all of
them may be one, Father, just as you
are in me and I am in you. May they
also be in us so that the world may
believe that you have sent me."

JOHN 17:20-21

During Holy Week, it's moving to watch footage of
worship services taking place around the world. As
believers from every denomination gather to worship Christ
in their native tongues, we get a glimpse of the unity Jesus
prayed for and a taste of what we can anticipate in eternity
(Revelation 7:9).

It's hard to fathom, but before going to the cross, Jesus
prayed for His disciples and future believers—in other words,

Jesus prayed for you! Specifically, Jesus prayed for unity in His church. Think about that for a moment. Jesus was on the brink of unimaginable suffering—and yet, the unity of His followers was so crucial to Him that He was praying about it hours before He was taken into custody.

Unity doesn't mean agreeing on every issue. The body of believers that make up Christ's church is beautifully diverse and represents every nation, ethnicity, social status, education level, political persuasion, and background. That type of diversity comes with varied opinions. God loves diversity—as the Creator of the universe, He didn't create two people exactly alike. But unity doesn't mean "sameness." Unity in Christ means people from every background agree that Jesus is Lord and worthy of our undivided love and worship.

Lord, I pray Your people will be unified in our love for You. Help me to be known for my love for You and for my brothers and sisters in Christ.

Service

Sitting down, Jesus called the Twelve and
said, "Anyone who wants to be first must
be the very last, and the servant of all."

MARK 9:35

T here's a saying that goes like this: "People hear what we
say, but they believe what we do." Jesus didn't just talk
about serving. He *actually* served people. Sure, people flocked
to hear Him preach about the kingdom of God. But Jesus also
fed hungry people, healed the sick, ministered to the grieving,
and served in every way. When people asked for help, He never
passed them by.

Jesus identified service as a hallmark of being His fol-
lower. To make His point, He modeled a lifestyle of service to
His disciples by washing their feet at the Last Supper. After
He was finished, He said, "Now that I, your Lord and Teacher,
have washed your feet, you also should wash one another's feet.

I have set you an example that you should do as I have done for you" (John 13:14–15).

In a world where the goal is often to race to the top of the social ladder, Jesus' words offer a different kind of challenge. It might mean arriving early to church to set up and staying late to sweep the floors. It might mean working in the nursery, serving food at a homeless shelter, cooking meals, visiting the sick, or building homes for the poor. If you keep your eyes open, you'll see people who need your help. Jesus said, "Now that you know these things, you will be blessed if you do them" (John 13:17).

Jesus, You are the Son of God and yet You modeled the lifestyle of a servant. Please give me the heart of a servant, and open my eyes to people and places where I can serve.

Jesus didn't just about serving. He actually *served* people.

Rest

"Come to me, all you who are weary and
burdened, and I will give you rest."

MATTHEW 11:28

One of the benefits of a good vacation is coming home
feeling clear-minded, focused, and energized for what's
ahead. Often, without meaning to, we get caught up in a hectic
pace and ignore our need for rest. If it's been longer than a few
days since we've felt fully rested, it's time for a reset.

During His earthly ministry, Jesus issued an invitation.
He said, "Come to me, all you who are weary and burdened, and
I will give you rest" (Matthew 11:28). When Jesus said "Come to
me," He was inviting us to draw near to Him. Following Jesus
means staying in proximity. It's impossible to follow Jesus and
experience His rest from a distance—we have to follow closely.

Physical rest is a vital part of soul care. If we are habitu-
ally fatigued, it impacts our physical, emotional, and spiritual

lives. Getting good sleep is an essential aspect of physical rest—but there's more to being rested than getting eight hours of shut-eye. Spiritually speaking, resting in Jesus means trusting Him with everything going on in our lives and trusting that He will work in ways we can't.

As Easter approaches, invite a slower pace into your rhythms. What habits are no longer serving you well? Why not replace them with beneficial ones? What would it take for you to get the rest you need and focus on habits that recharge your soul? Jesus has invited you to a lifestyle of resting in Him— you've got permission to slow down and refill.

Jesus, thank You for inviting me to draw near to You and experience Your rest. Help me to follow You closely and rest in Your care.

Following

Jesus means staying

in proximity.

Anticipate

But as for me, I watch in hope
for the LORD, I wait for God my
Savior; my God will hear me.

MICAH 7:7

Sometimes winter can feel endless. Days on end without a glimmer of sunshine. Not a flower in sight. The gray skies and whipping wind can take a toll after a few months. By the time February and March roll around, it feels like the season will never end. And yet, of course, it always does. We know spring is coming soon, and we wait with anticipation for the very first bloom.

The return of Christ is as sure as the springtime. How do we know? He told us. And if He fulfilled His promise to come to this earth once, surely He will come again.

How does your anticipation of the coming Christ affect how you live? Your circumstances may ebb and flow, but keep

reminding yourself of the reality that is to come. Let that stir anticipation in you. Let that anticipation help you refocus and prioritize what actually matters in your life. Do you really need to spend that extra hour or two working at the office or making your house tidy? Or is your time better spent elsewhere?

And for days when it feels gray—because all of us are prone to our own personal "winters"—pray that God would give you a glimmer of the spring to come. Call a friend. Seek out a therapist. Go for a walk. Do some breathing exercises. Pray. Let anticipation of Christ's return keep you going until your heart experiences light again.

Lord, help me to approach each new day with anticipation, remembering that You promised and assured us of Your salvation. I recognize that this life is a gift. Help me to make the most of my days as I anticipate spending eternity with You.

The

return

of Christ is as sure as the

springtime.

Childlike

He called a little child to him, and placed
the child among them. And he said:
"Truly I tell you, unless you change
and become like little children, you will
never enter the kingdom of heaven."

MATTHEW 18:2–3

Take a second and think back to an Easter egg hunt at your church or a family celebration. Recall the little ones running around in pastel-colored clothing, quickly filling their baskets with ridiculous quantities of sugar. In the excitement of it all, maybe a child even paused to ask for help to find that last remaining egg. It's a fun activity for kids planned by people who care about them.

When Jesus told His disciples they needed to "become like little children," He was referring to their faith and humility. Little kids at an Easter egg hunt aren't cynical or doubtful, and

they aren't afraid to ask for help. They're earnest, expectant, and pure of heart.

Think about the way you approach God. Do you approach Him with faith or doubt? Do you need to reclaim some of your childlike qualities? As we get older and experience more hardships in life, it's not uncommon to waver in our expectations and be more hesitant to ask for what we need. But Jesus invited us to become like little children with Him. He understands why you feel the way you do, but He does offer a better way. Jesus wants you to be free and have the faith of a child. He longs for you to trust Him and be confident that He actively cares for you. You can relax knowing that He has planned the entire story, a story that has a great ending—eternity with Him.

God's got this. So let go and enjoy the ride.

Jesus, help me to be more childlike in my faith and ability to trust You. Let me rekindle the confidence that You will always take good care of me and that You enjoy my earnest expectation.

Freedom

Now the Lord is the Spirit, and where the
Spirit of the Lord is, there is freedom.

2 CORINTHIANS 3:17

Sometimes it's easy to forget our freedom in Christ. We often trick ourselves into believing that Jesus' work on the cross was not enough. That whatever we've done in our past or maybe even in this present moment is outside the bounds of what God can forgive. It's tempting to try to earn God's forgiveness or love by committing ourselves to a set of rules we think will impress Him.

But Christianity simply doesn't work that way. There is nothing we can do to gain God's love. We already have it.

Paul told us that we are free in the Holy Spirit. If you are a Christian, that verse is for you! This Easter, no matter what regrets you have in your life, the Lord is inviting you into a new way of living freely in His Spirit. As you continue in your

faith, your character is going to increasingly become more and more like Christ's. You become like the One you love, and He is transforming you into His image.

So today, let go of the idea of your old self. Let go of the way you used to relate to God. Embrace God's forgiveness. Embrace His grace. Embrace freedom. The gospel makes way for light living.

Jesus, thank You for saving me from the captivity of sin. Help me to obey You and walk in the freedom You died to give me.

Fasting

"But when you fast, put oil on your
head and wash your face, so that it will
not be obvious to others that you are
fasting, but only to your Father, who is
unseen; and your Father, who sees what
is done in secret, will reward you."

MATTHEW 6:17-18

The Lenten season is an ideal time to slow down and focus on our relationship with God. After all, the cross of Christ is something that calls for contemplation. But a lifestyle of constant scrolling, binge-watching, news alerts, and information overload can make it difficult to focus. If we want to lean in and focus on our relationship with God, we might consider participating in a modern-day fast.

When we think about fasting, we often associate it with abstaining from food for a specific amount of time, but we can

also fast from things like social media, TV, caffeine, or entertainment. Initially, that might not sound beneficial, but fasting makes us aware of how many distractions we have in our lives. It also helps us remember our dependence on God and our reliance on Him for our emotional, spiritual, and physical well-being.

When we simplify, we find freedom. We often get caught in cycles where we think we need screens or sweets or excess exercise to help us feel happy. When we break that cycle and realize what we're really looking for, we start to find healing and do some deeper emotional work.

Maybe your fast is the beginning of a longer journey that can be done with a church leader or therapist. No matter what, your fast is an active practice of trusting and experiencing God, as you experience His faithfulness to fulfill you.

Lord, I need You more than I need to be entertained—I even need You more than my next meal. Teach me to fast and pray in a way that worships You and brings You glory.

Love

> "A new command I give you:
> Love one another."
>
> JOHN 13:34

In the sporting world, when you hear the name Tiger Woods, you undoubtedly think of golf. Venus and Serena Williams bring the game of tennis to mind. In the world of music, Dolly Parton and Whitney Houston are known for their inspiring singing. These people are celebrated for their work because they spent thousands of hours refining their skills and giving their whole talent over to their craft. It's earned them a reputation for being the best in their fields.

Interestingly, Jesus wanted His followers to have a reputation for a specific quality: love. Jesus said, "A new command I give you: Love one another. As I have loved you, so you must love one another. By this everyone will know that you are my disciples, if you love one another" (John 13:34–35).

Notice that Jesus didn't say His followers would be known for their status, their beauty, their wealth, or their kids' achievements. Jesus wasn't interested in pomp and circumstance. Instead, the litmus test of being a Christ follower is love. The best-known passage in Scripture is "For God so loved the world that he gave his one and only Son, that whoever believes in him shall not perish but have eternal life" (John 3:16).

To love is a verb. It is active. It is giving. It requires sacrifice. It requires that we be in connection with others and continually work for their good. To love like Christ entails extending beyond our personal circles to be among people who are not like us. It requires us to give exuberantly and graciously. Will you be known for that? Precious few of us will.

So this Lenten season, commit to one active way of loving your neighbor. Join an organization through your church or community. Or perhaps invite your actual neighbors over for regular dinners and get to know them. Volunteer at a nursing home and coordinate crafts. Love doesn't have to be expensive or fancy. It can be simple and pure. Let it look like *you*. Pray that God would guide you as to where your time may be best spent, and keep an ear open for where He's calling your love to be put into motion.

Lord, help me to be known for how well I love You and other people.

The litmus

test

of being a

Christ follower is

TWENTY-NINE

Community

They devoted themselves to the
apostles' teaching and to fellowship, to
the breaking of bread and to prayer.

ACTS 2:42

In some ways, people have never been more connected, yet loneliness has reached epidemic proportions. God created us to be in community with Him and other people. But what is real community?

Jesus was always spending time with people. He invited His disciples to follow Him (Matthew 4:19) and the weary to come to Him (11:28–30). Jesus attended weddings and worship services, went to people's homes, and shared meals. Not only did He embrace being around people, but He made people comfortable in His presence. Jesus is the Son of God and Savior of the world, yet He prioritized community.

After Jesus ascended to heaven, the disciples continued

to be active in community with one another. Acts 2:42 says, "They devoted themselves to the apostles' teaching and to fellowship, to the breaking of bread and to prayer." These new believers didn't meet just once a week to attend church. They experienced life together by caring for each other, studying the Scriptures together, and encouraging each other in their faith. You don't have to be a social butterfly to fellowship with other believers—you just need to keep showing up. God designed everyone—introverts and extroverts alike—to be in community. The Christian life is not designed as a solitary experience.

Use this season as an opportunity to attend at least one gathering where you can meet someone new. Whether a one-on-one coffee or a small-group event, connect with someone new. There's a good chance that someone else is looking for community too. Set aside distractions and ask questions—all the things you'd want to experience in a friend.

The most daring thing to do in our culture? Follow up! Building a community takes time, and it can be frustrating and discouraging if you feel you're not connecting. If you already have a robust community, consider how you can invite new folks in. You never know when your simple invite may be the life raft someone needed in their loneliness.

Lord, above all else, help me to live in Your presence and live in community with my brothers and sisters in Christ.

Reconciliation

Jesus answered, "I am the way and
the truth and the life. No one comes
to the Father except through me."

JOHN 14:6

Have you ever said or done something you instantly regretted? You know the feeling—that sinking sensation in your gut when you know you've done something wrong, but there's nothing you can do to take back your actions. Your only hope is reconciliation. If you've found yourself in this situation, you aren't alone.

We all need reconciliation. It's in our very nature. In fact, the Bible teaches that we all need reconciliation with God. The apostle Paul wrote, "For all have sinned and fall short of the glory of God" (Romans 3:23).

When we want to reconcile with a friend, we often try to make it up to them, maybe with a letter or a small gift to try to

assure them of our repentance. But with Jesus, we don't have to do any of that. Although we are the ones who have sinned, it was Jesus who covered the debt for reconciliation on the cross.

No other religion works this way—where people sin and God reconciles. It doesn't make sense by our earthly standards, and it's tempting to believe we have to make it up to God somehow. But Jesus said, "I am the way and the truth and the life. No one comes to the Father except through me" (John 14:6).

As you prepare your heart and mind to celebrate Easter, spend some time contemplating what Jesus has done for you. Celebrate how good your life can be, knowing He is always reaching out, arms wide open, to reconcile you to Him. Repent, accept His grace, and keep going forward, knowing nothing can separate you from His love.

Lord, I praise You and give You thanks—because of You, I am reconciled to the Father. Jesus, You are the way, the truth, and the life. Help me live my life joyfully in response to that reality.

Jesus is always

reaching

out, arms wide open, to

reconcile

you to Him.

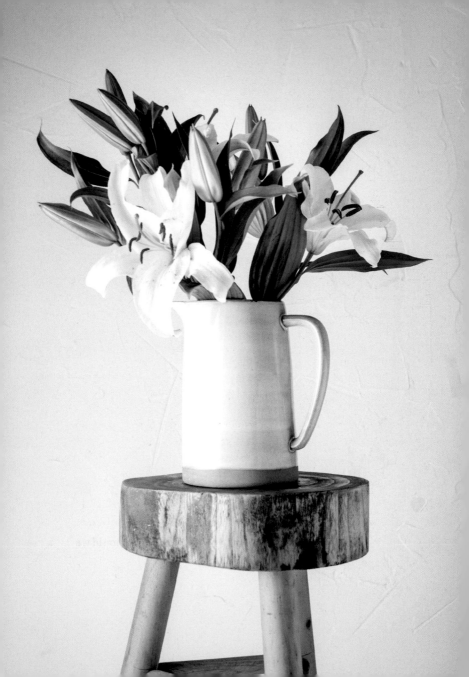

THIRTY-ONE

Surrender

I have been crucified with Christ and
I no longer live, but Christ lives in
me. The life I now live in the body, I
live by faith in the Son of God, who
loved me and gave himself for me.

GALATIANS 2:20

The word *surrender* often has a negative connotation. A battle is lost—time to admit defeat. But what if the One we're surrendering to has our best interest at heart? Someone who is protecting us? Someone who is on our side? Suddenly surrender isn't so bad.

Naturally, we have ideas about how our lives should go and what we would like to happen. But we already know things don't always work out the way we think they should. So how should we respond in those instances?

The apostle Paul said, "I have been crucified with Christ

and I no longer live, but Christ lives in me" (Galatians 2:20). To be "crucified with Christ" means to surrender ourselves to obey God. Jesus loved us enough to give Himself on the cross for us. With that in mind, we can confidently assume He knows what's best in every other aspect of our lives.

If you're in a season of needing to let go of something that hasn't been serving you, ask God to help you. Depending on what you need to surrender to Him, it may take time and persistent prayer to discern the answer. It's often in the surrender where you discover new ways that God is kind and loving to you. God will be waiting and ready to help you let go of what you thought you needed so that you can discover something much better.

Jesus, give me everything I need in order to surrender to You. Help me know You so well and trust You so much that I can confidently pray, "Not my will, but Yours."

Peace

"Peace I leave with you; my peace I
give you. I do not give to you as the
world gives. Do not let your hearts
be troubled and do not be afraid."

JOHN 14:27

If there had ever been an appropriate time for Jesus' disciples
to rally around Him and offer encouragement, appreciation,
and prayer, it was before Jesus went to the cross. However, it
was Jesus who was giving encouragement and instruction and
praying for His followers. He told them, "Peace I leave with
you; my peace I give you. I do not give to you as the world gives.
Do not let your hearts be troubled and do not be afraid" (John
14:27).

The word *peace* doesn't refer to a serene feeling. It refers
to the Hebrew word *shalom*, which was often used as a greet-
ing or pronounced blessing on someone who was in a right

relationship with God.[1] Jesus' peace is not dependent on out-ward circumstances. We can experience His peace when we are sick or well, employed or looking for work, rich or broke, single or married, heartbroken or happy. Jesus' peace holds in all circumstances—even in Gethsemane.

When Jesus told His disciples not to be afraid, it's because they were! He didn't condemn them for that fear, but He gave them something that would supersede the fear: His peace.

Two millennia later, what does that mean for us? It means Jesus still offers us that same peace. We get to experience Him when we pray, read the Bible, meditate on His character, or wonder at His creation.

What would it look like to prioritize peace this Lenten season? Commit to spending time with God during pockets of your day—while getting ready, on your commute, or preparing dinner—and focus on your relationship with Him. Ask God to bring His peace into your life.

Lord, I want to live in Your peace. Help me to manage my thoughts and focus on Your promises so I don't live in fear.

Jesus'

peace

is not dependent on outward

circumstances.

Sacrifice

"She did what she could. She poured
perfume on my body beforehand
to prepare for my burial. Truly I tell
you, wherever the gospel is preached
throughout the world, what she has done
will also be told, in memory of her."

MARK 14:8–9

As the clock ticked toward Calvary, Jesus was in the town of Bethany, located two miles east of Jerusalem, where He and His disciples would eat the Passover meal. Jesus was reclining at a table when a woman named Mary came and anointed Him with expensive perfume that was worth three hundred denarii—almost a year's wages for a common laborer.[2]

Jesus was moved by the sacrificial gesture, but others accused the woman of being wasteful. Jesus defended her, saying, "She did what she could. She poured perfume on

my body beforehand to prepare for my burial" (Mark 14:8). Interestingly, the phrase "she did what she could" is very similar to what Jesus said in another story in Scripture about a widow who donated a small amount—but in doing so, gave all she had (Mark 12:41–44). Jesus commended both women, and even though the amount of their contribution varied dramatically, they both gave sacrificially.

Days later, Jesus demonstrated the greatest act of sacrificial giving ever bestowed on humankind when He gave His life on the cross so that sinners could be reconciled to God (Romans 5:8–11). Jesus was all in. When He saw a need, He never provided the bare minimum but always went above and beyond what anyone anticipated.

The sacrifice of God always comes from love, not guilt. Who do you love? What would it look like to give sacrificially to that person? It may be with your finances, but it doesn't have to be. What does it look like to give sacrificially of your time, skills, craftsmanship, or care? You can be creative with how you live this out; just know that you will be changed for the better if you do.

Lord, You did not give me Your bare minimum—You gave it all. In return, help me to give sacrificially.

The

sacrifice

of God always

comes from

love,

not guilt.

Jesus came to

triumph

over sin by way of the

cross.

Triumph

"Do not be afraid, Daughter
Zion; see, your king is coming,
seated on a donkey's colt."

JOHN 12:15

Palm Sunday marks the beginning of Holy Week and cele-
brates what is known as Christ's triumphal entry into
Jerusalem. When we think of a modern-day triumphal entry,
we probably imagine a parade, maybe a high-school march-
ing band, a Rolls-Royce, and crowds lining the streets to get a
glimpse of a royal visitor. But Jesus wasn't a typical king.

Jesus chose a humble donkey to ride into the gates of
Jerusalem. By doing so, He fulfilled a prophecy foretold by
Zechariah some five hundred years earlier (Zechariah 9:9).
He was openly declaring His identity as the long-awaited
Messiah. Even seeing Him on His humble donkey, the crowds
spread their cloaks on the ground and waved palm branches as

an act of reverence. This was the moment they had waited for—the Messiah had come.

But the crowds would soon learn they had misunderstood Jesus and His mission, and many turned on Him. They had anticipated a great military leader, but Jesus didn't come with a sword. Instead, Jesus made a humble and peaceful entry. He hadn't come to take the world by force and military might. Instead, He came to triumph over sin by way of the cross.

The most triumphant week in the Christian calendar starts with a humble donkey. As Christians, we know that our version of triumph may not look like the world's, but it can be alluring to get caught up in our culture's "triumph" of success. A bigger home. A promotion. More political power for our group. Winning every argument.

Where in your life do you need to adopt a more donkey-like approach? Have you let the world define your ideas of success, or are you following the Christian example of sacrifice and surrender? It can be difficult to lead a humble life, but by Christ's model we know it leads to triumph and goodness.

Lord, You triumphed over sin and death on the cross. Help me to remember that Your ways of doing things might differ from my expectations, but You are trustworthy.

Victory

Where, O death, is your victory?
Where, O death, is your sting?

1 CORINTHIANS 15:55

I f you've ever lost a loved one, holidays can be particularly difficult. Death wasn't part of God's original design, and it feels unnatural because God made us for everlasting life (Ecclesiastes 3:11). Jesus was angered by death, and it's a natural reaction. And yet, our anger can be temporary because, as Christians, we know our longing for everlasting life will be fulfilled because Jesus conquered death at Calvary.

As the Son of God hung on the cross, the last words He spoke were "It is finished" (John 19:30). At that moment, Jesus' mission was victorious—He had conquered sin and death! Later, Paul wrote, "The sting of death is sin, and the power of sin is the law. But thanks be to God! He gives us the victory through our Lord Jesus Christ" (1 Corinthians 15:56–57).

Right now, as believers, we are living in the tension between the "already and not yet." That means Christ has already secured victory over sin and death, but not everything has yet come to fulfillment. The apostle Paul described a time in the future when we will be reunited with loved ones, and our bodies will be imperishable and immortal (1 Thessalonians 4:17; 1 Corinthians 15:53–54).

As you prepare for Easter, spend some time contemplating the life, death, and resurrection of Christ. Invite mourning in, if you need to. Celebrate the reality that you serve a risen Lord who conquered sin and death. A time is coming when death will be no more—the victory has already been secured.

Lord, I praise You because You have power even over death and sin. Teach me to anticipate eternal life and live in a way that demonstrates that death doesn't get the last word.

Forgiveness

In him we have redemption through
his blood, the forgiveness of sins.

EPHESIANS 1:7

Have you ever witnessed a young child lying to a parent? Perhaps the parent asks if he ate some chocolate, and he denies it while the evidence is on his face. Or she promises she finished eating her veggies, as the dog gobbles up the remnants under the table. Parenting is one big act of forgiveness!

If we're in any relationship long enough, we'll need to ask for forgiveness and extend it to others. In the Christian life, forgiveness is a daily act. It's an ongoing process that's a foundational aspect of the Christian faith and one Jesus modeled during His ministry on earth.

As Calvary drew near, Peter promised Jesus his faithful devotion. But hours later, in Christ's darkest hour, not only did Peter deny Jesus, he did it three times. After the third

time, Peter wept bitterly (Matthew 26:75). Can you relate? Have you ever been so embarrassed by what you did that you couldn't comprehend how God could forgive you?

The good news is God's forgiveness reaches every aspect of sin. You can't out-sin God's willingness to forgive. Imagine Peter's frame of mind, knowing he had sinned against Jesus just hours before Jesus gave His life. The guilt must have felt crushing. But notably, after Jesus was raised from the dead, He didn't avoid Peter—He sought Peter out, forgave him, and restored him to ministry (John 21:17).

It's likely you've needed to confess far more serious sins than eating some chocolate or not finishing your vegetables. Maybe you're more like Peter and feel the weight of guilt crushing you.

Christian, rest easy. If you confess your sins and ask for forgiveness, God forgives you on the basis of Christ's death and resurrection (1 John 1:9). In addition, it's your role to be a model of Christ in this world and practice forgiving others too. This may be something you seek God's help with time and again. But it's God's will for you to forgive, and He will help you forgive others in the same manner He forgave you.

Lord, thank You for forgiving me of my sins. Help me to accept Your forgiveness and forgive myself. Fill me with Your power and grace to forgive the way You have forgiven me.

You can't

out-sin

God's willingness to

forgive.

Fulfilled

Jesus took the Twelve aside and told
them, "We are going up to Jerusalem, and
everything that is written by the prophets
about the Son of Man will be fulfilled."

LUKE 18:31

During the events of Holy Week, as bizarre as the situation
must have seemed to the disciples, things were going
exactly as God had planned. Imagine how the Twelve must have
felt after they'd left their previous lives to follow Jesus, and now
Jesus was predicting His death and resurrection (Luke 18:28,
33). They'd followed Jesus for three years, heard His teachings,
and seen His miracles. How could it be that Jesus was about to
be crucified? They didn't understand at the time, but they soon
would (Luke 18:34).

The Old Testament writers had revealed that the Messiah
would suffer, and now those prophecies were coming to pass

(Psalm 22; Isaiah 53). As the events leading up to Calvary unfolded, everything happened the way the Scriptures said it would. Jesus had said, "Do not think that I have come to abolish the Law or the Prophets; I have not come to abolish them but to fulfill them" (Matthew 5:17).

When life is spinning out of control, it's tempting to think that things are not going as planned. We argue that God didn't warn us about this. When we don't understand why things are unfolding the way they are, we must remember that God fulfills His promises—and He is good. We don't always understand, but He is faithful. We can move forward with confidence, knowing He is trustworthy.

Lord, thank You for the Scriptures. Jesus, I praise You for fulfilling the Old Testament Law and Prophets. Help me to trust You in every circumstance and rely on Your promises.

Lament

As he approached Jerusalem and
saw the city, he wept over it.

LUKE 19:41

As we anticipate Easter, we might feel compelled to rush
past Friday to get to Sunday. After all, Good Friday is
bleak and upsetting. We know Friday isn't the end of the story,
so why not fast-forward to the good news coming on Sunday?
The truth is, to understand the magnitude of God's redemptive
story, we need to linger on the day when Christ was crucified.
It's necessary to pause at the horror of Golgotha and take it all
in. It's important to sit with the injustice that put Jesus on the
cross, the sin that nailed Him there, and the love that motivated
Him to carry out His mission. We can allow the emotions to rise
up in our souls and pour down our cheeks. It's appropriate for
Calvary to bring tears and even lament.

Lament is a concept that is often overlooked because, for

the most part, our culture is uncomfortable with open expressions of grief and sadness. But there's a category in Scripture called the Psalms of Lament—they teach that it's safe to come before God in total transparency. The Psalms of Lament demonstrate that we are invited to lay our burdens and sadness before God—we are encouraged to ask questions and even complain if we need to. However, we're often uncomfortable with the idea of going to God with negative emotions. Shouldn't we just be able to get over hard things? Stir up some faith and move on?

No, and Jesus doesn't need us to. Lamenting in His presence is part of this life, and only He can transform our lamenting into joy. He is no stranger to lament, and we won't be either. If you're going through something particularly difficult this year, lean into Good Friday. Rejoicing will come again, but for today, feel free to weep in the presence of a holy God.

Lord, I pray You will help me understand the enormity of God's redemptive story. Help me to feel it at a deeply personal level.

We are

to lay our burdens and

before God.

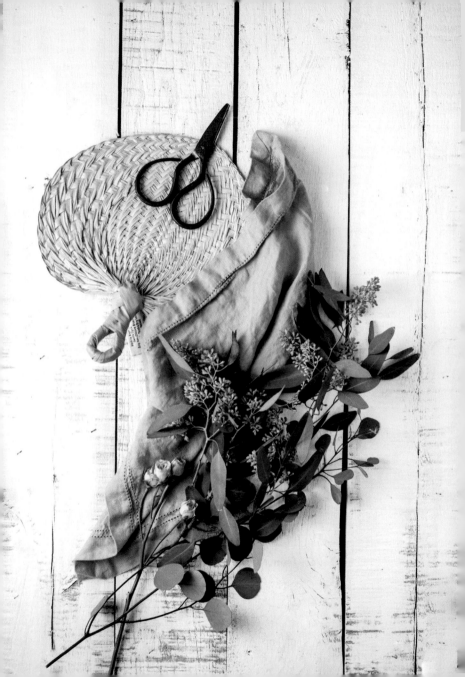

Waiting

"See, I am doing a new thing! Now it springs up; do you not perceive it? I am making a way in the wilderness and streams in the wasteland."

ISAIAH 43:19

Scripture mentions little about the Saturday following the crucifixion. The only glimpse into Saturday is a few short verses that give the account of the chief priests and Pharisees asking Pilate for permission to post guards at Jesus' tomb (Matthew 27:62–66). From the disciples' perspective, Saturday was dreadfully silent. Undoubtedly, they were reeling from the events of Friday. It's safe to assume they were consumed with grief, guilt, confusion, anger, and fear. As they waited, the future looked hopeless. They didn't know they were less than twenty-four hours from the greatest event in world history.

So why is Saturday significant?

We, too, will encounter situations that don't go as planned. We might even feel hopeless. We'll be unsure how to move forward, we won't have answers, and we'll be left to wait. And as we wait, we'll experience the silence of Saturday. When we're waiting, it's tempting to associate silence with a lack of progress. When we can't see or sense God working, we might assume He's not. But even when we can't see a way out, we should never assume there isn't one. God possesses resources we aren't aware of, and He has plans we don't know about yet.

Are you in a season of uncertainty? Are you waiting for guidance? Are you coming through an emotional upheaval that has left you reeling? You have good reason to hope. Don't fear the silence. Lean into the waiting. Sunday is coming.

Lord, teach me to trust You, especially in seasons of waiting. Help me to wait with hope and faith that You are working, even when I can't see what's happening.

God possesses

resources

we aren't aware of,

and He has

plans

we don't know about yet.

Risen

Why do you look for the living among
the dead? He is not here; he has risen!

LUKE 24:5-6

Epic, groundbreaking, world-changing. Every word falls
short of capturing the magnitude of Easter Sunday. It's
the most significant event in world history and in the lives of
Jesus followers. Christ is risen from the dead!

It was early Sunday morning when the women went to the
tomb to tend to Jesus' burial site. As they approached the tomb,
they were shaken because they realized the stone had been
rolled away, and when they entered the tomb, they couldn't
find the body. Two angels approached them and asked, "Why
do you look for the living among the dead? He is not here; he has
risen!" (Luke 24:5–6). Then they remembered Jesus had said,
"The Son of Man must be delivered over to the hands of sin-
ners, be crucified and on the third day be raised again" (v. 7).

The powers of darkness had taken their best shot at Jesus as He hung on the cross. And yet, things unfolded precisely the way Jesus said they would (Matthew 16:21). Death could not hold Jesus in the grave, and on the third day, He stepped out of the tomb. You serve a risen God who is as alive today as He was on that resurrection Sunday. No power of hell and no force of evil can prevail over Him! Rejoice that you belong to Him and that with Him all things are possible!

It is because of the physical resurrection of Christ that you can have hope. You can have faith. You can have freedom. Your life is altered because of what you're celebrating today. This is not just a feel-good story. This is the story that rewrites *your* story. When Christ rose, He proved that He is Lord. His promises are true. His Word can be trusted. His relationship with you is ever-fixed and abounding in steadfast love. And you can walk freely in mission with Him forever.

Lord, I praise You, I worship You, and I thank You. I rejoice that You are alive and in control of all things.

You serve a

risen

God who is as alive today

as He was on that

resurrection

Sunday.

1. *CSB Study Bible* (Nashville: Holman Bible Publishers, 2017), 1697 footnotes.
2. *CSB Study Bible*, 1586 footnotes.